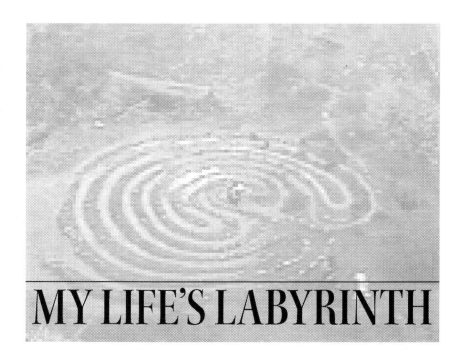

MY LIFE'S LABYRINTH

by

IRIS M FORD

A JOURNEY THROUGH LIFE WITH JESUS

Joy even when everything seems to be going wrong!

 www.trafford.com

North America & international
toll-free: 1 888 232 4444 (USA & Canada)
phone: 250 383 6864 ♦ fax: 812 355 4082

APPRECIATIONS

Philemon 1:6. *"I pray that you may be active in sharing your faith, so that you will have a full understanding of every good thing we have in Christ."*

To Jesus Christ, my Lord and Saviour for His directions along My Life's Labyrinth.

- *To Catherine Held, for her insights and help in writing this book and for some of the GOING DEEPER sections.*

- *To Sally Isakson for her life story in Chapter 4 showing how the Holy Spirit, aka the Holy Ghost, surprised and helped her.*

- *To Jan Korvemaker for her personal openness in writing some of the GOING DEEPER sections.*

-*To Georgina Houghton for editing this manuscript, and for her ability to see mistakes and correct them.*

-*To Ruth McCowan for the lovely scenery pictures included here.*

-*To <dreamstime.com> for the symbolic images everywhere.*

THANK YOU AND MAY GOD BLESS YOUR JOURNEY!

Contents

PREFACE

This journey, which we call life, is like wandering through a labyrinth. One can feel lost, or misdirected. At another time one can even be galloping along laughing and having a good time. Other times all looks scary and dangerous. Where are we really safe? Some faces are intent, noting everything along the way; still others are so sad it makes one want to cry just looking at them. A few people walk through with utter confidence; they look calm and are always keen to try something new and different. I wonder where I am along this journey we call life? Where am I going?

Christ is also with us along the labyrinth, showing us which way to walk, where to be cautious. Christ, however, does not remove us when we are lost; He just remains by our side, so it is scary sometimes. Christ also walked this way before us, and His way included a cross. Could there be a tragedy ahead for us? How will we do? If there is another world-wide war, how will it work out for us? How does one control anything these days with social media reporting all sights and calamities world-wide almost immediately?

The world is changing, but I pray we all will know continuous peace, and grow in faith as we walk with

Christ along our Life's Labyrinth. Each day is special, but it can also include all that this life holds here on earth. Don't fret; don't be worried or afraid. When life is over, when we have continuously walked with Jesus through it all, we will finally and safely reach our Centre – our Spiritual Home!

As I write these words I am recovering from a serious accident. I was hit by a truck, striking with great force down my right side. It broke my collar bone and crushed my right hip. It has enforced twelve months of recovering, but the Lord has made good use of this enforced rest. I have been working on this book, day by day, moment by moment, but I can only type a few minutes at a time.

The road is hard to endure at times, we need to pray for each other and share a helping hand. Some of our fellow walkers will see right through us and go another way. Are we really following Christ, does it show? Do we talk about Christ along the way? Are we different? Do we care for other people, giving a helping hand and a kind word, or do we walk silently, intent on finding the way through, but careless about another's feelings?

People on today's modern, secular labyrinth, tend to go about their own business and ignore those walking beside them. They push and shove others aside, intent on getting through as fast as possible. As for us, we may feel badly when our children and grandchildren don't go to church, but rarely speak of Jesus to them. So I ask myself, why have they left their faith foundations? Part of the blame is ours as many of us have come to this point by way of a culture

that says: "Don't wear your faith on your sleeve, it is private." So we rarely speak of Jesus to our families, or among our friends. We leave all that kind of thing to ministers and those trained in theology and the Bible. But now, as we walk the Labyrinth of Life with Jesus we try to understand what Jesus told His disciples and what He meant by His words in this our day, and we seriously look for ways to share Christ's presence with family and others. Prayerfully, it is not too late.

The labyrinth, as an image of life's journey, is actually quite appropriate. It is different from a maze. Whoever reads this book first looks at the labyrinth picture and wonders, how do I walk with Christ through this? Every labyrinth offers a way to meditate and think about one's life, praying as you walk along. This is also true of the walk with Christ in daily life; we talk with Him along the way. Walking a labyrinth with Jesus holds up a mirror reflecting back to us not only the light of our finest hour, but also the grief of our worst hour. All is seen, understood and forgiven by Christ.

There is only one centre to a labyrinth, but the flat, gentle path carefully leads us there. The centre for a Christian's life, of course, is Heaven, but a labyrinth also leads us to understand our personal centre. On Christ we stand or fall, He is not only our centre but also our foundation. This we come to understand more clearly as we meditate along Life's Labyrinth.

The historic labyrinth is some 3500 years old, yet today it offers us time to set aside all else to meditate and pray. My prayer is that as you read this book, and follow the selected Sayings of Jesus, you will pray

your way through each one. Above all, let's invite Christ to walk along our labyrinth with us. He has said that all who come to Him He will not cast out. He is listening, He is there beside you. Look!

INTRODUCTION

SHARING CHRIST IN AN INDIFFERENT CULTURE

I was in our car watching people enter a grocery store when it hit me: what we have here are many cultures offering many, many choices - just like on the grocery shelf. Canada prides itself on being multi-cultural. But this attitude often means that Christianity also is but another commodity on a grocery shelf to be taken or ignored. What do we face here then? We face individualism, disinterest, ignorance and even idealism. Many focus on money and secular needs only, leaving their lives spiritually empty. I watch sadly as churches close.

I am a church daughter. As a minister's daughter I grew up next to the church building in Bermuda. It grieves me no end to hear of churches closing as

yesterday's devotional on the Presbyterian Church in Canada's webpage was headlined CHURCH FOR SALE. Lots of churches are closing. What has gone wrong with us? Are we failing?

The future of the western world is now spoken of as THE COMING DARKNESS. Has the light of Jesus gone out, out of all us church folk? I was praying about this, and had started to write this book back in early spring when my accident with the truck happened and I was almost killed. The truck just broke my shoulder in four places, but it made it hard to type this manuscript. Was this an attempt of the evil one to silence me? It sure made it difficult to type, but God's message kept coming and I just limited my typing to fifteen minutes at a time.

God's message for all of us is this: we have all been promoting church, sometimes inviting people to the church building or programmes, but to no avail. People see church as just a boring organization and they are not impressed. Too often also we have left Jesus Christ out of our conversation with people, especially people outside of the church. Yet Jesus is walking through life with us. Why don't we then talk to Him and to others about Him? It is partly a cultural thing I know: English and Scottish culture has conditioned us not to wear our personal beliefs on our sleeves, it is too important for that careless affront. So most of us love Jesus but rarely talk about Him.

Children grow up thinking only the minister and their Sunday school teacher know how to talk about Jesus properly. There are also many blocks stopping

us parents from sharing - too little time or too much work. Even I have been thus affected, but I tried to bridge the gap. I started every day in active ministry standing at the window praying down the membership list, praying for my people. Over the years we have done extremely well giving money to send missionaries overseas, but what about our home turf? Who goes out to others here? We do, or are supposed to. At least Jesus told us to start on home turf, i.e. Jerusalem.(Acts 1:8) How did He start? In the Temple at twelve years old! So, we start in Church worship, right! Then go out to others.

This book suggests that we go to strangers and neighbours, and share the actual Sayings of Jesus. He said them distinctly, on purpose, so people would remember them. There are over thirty such Sayings of Jesus. We know, through His Word, that His Spirit is always here with us just as He was over 2000 years ago. Jesus is walking with us along this Labyrinth of Life, speaking with all generations. What is He saying today? How does He come across? Do people today understand His words?

You will find that many people are simply not interested in any religion. They have many excuses for their lack of interest: too busy, their life style moves too fast, and split shifts means they can't get to church on Sunday even if they wanted to. Meanwhile, this is a strange, uneasy society. The media prints everything possible to increase that feeling of disease.

Years ago Jesus sent his disciples on a journey, a labyrinth that must have warned them that hard times were ahead. If you are sensing that your labyrinth is

full of turns that trouble you then read Matthew 10 right through. It may tell you something about our day, our journey. It is not easy.

Walking along our Life's Labyrinth is a deeply spiritual journey as we centre down into ourselves. We walk quietly. Our souls are moved with grace, and we recognise that something is affecting us deeply. We are realising that we walk our Life's Labyrinth with Christ! We walk as He walked. We talk as He talked and we share one another's pain with His encouragement. Talking as Christ talked along our Life's Labyrinth means we are sharing our Christian faith as we share Christ's love. This walk today is a different challenge from that of the people who walked with Jesus during His time on earth, but many turns are similar to Jesus' earthly journey. You will recognize them along the way.

We need to be aware, though, that we do not walk alone. Other people are on this journey too, people of all ages from every country. Many people just dash by us non-caring; they stare and run on, barely pausing. How do we share with all ages today? The younger generation are mostly on their own, relating only among themselves by internet. Communications these days are instant and world-wide. Making the situation worse is the problem that many of the main-line churches have lost contact with youth, so how do you and I communicate? This is the biggest challenge of today, and it affects all walks of life. The interesting thing though is that youth today talk a lot with their grandparents, the communication gap seems to be with parents. How does one close the gap?

You and I care a lot, but we most often walk silently. We are aware of another's hurt and pain, but only offer a comforting hug. As we feel a teen's confusion how do we share Jesus' yoke, His pain? Jesus, after all, shares our pain and concerns. We carry nothing alone. In Matthew 11: 28–30 we read of one of Jesus' most famous and lovely sayings. "Come to me, all you who are weary and burdened, and I will give you rest. Take my yoke upon you and learn from me, for I am gentle and humble in heart, and you will find rest for your souls. For my yoke is easy and my burden is light." As we take His yoke upon our backs our load is greatly lightened.

The many pictures included in this book are to help the reader meditate, drawing each one deep into their souls while gazing on the peaceful scene. Try one, it will direct your soul into green pastures where you can go deep and find your spiritual being, alive and well. You can pray for another's pain as you gaze and wonder.

Jesus draws us close as we walk together, and when we ignore another's pain and suffering it is not the road that Jesus took. Also, claiming ignorance of another's pain is not the route we can go today with Him. We need Jesus' help therefore when sharing our story as it affects others, but we need to understand our story, especially how Jesus has affected us! We are walking through life with Him, right? Then how does personally knowing Jesus affect our story? How can we tell it, how can we share it with another? This book looks at sentences Jesus used when speaking with his followers while here on earth. We can use

modern day translations in ways that our family and friends can understand in today's world. Try it, Jesus will speak through you, using one of His Sayings.

Let's understand what life's journey is like now as a believer in Jesus. No problem is ours alone, Jesus shares our load as we share His load. The yoke we carry for Christ is to tell others we meet along our Life's Labyrinth about Jesus and His sacrifice. So, we need to tell another person how Jesus' sayings have completely changed our life, and Jesus will influence all we share with His Spirit. Jesus' words are not just another commodity on a grocery store shelf, but a life changing challenge that draws us through this labyrinth with Him until we reach the centre of the labyrinth – home with Christ Jesus – together. It may be rough at times, or like a rushing waterfall, but it is our Life's Labyrinth. Take care and pray!

CHAPTER ONE

THE MISSING LINK

Having spent a great deal of time thinking and praying through what it means to be on this journey with Christ, I must acknowledge a worriment: there is a missing link in the lives of most of us. As Presbyterians, and in many of the main line denominations, we have been very, very good at sending missionaries overseas. But what about here? How do we spread the Gospel at home, in this country? For many years we have been charged with spreading the Gospel through the whole world. We have also given millions of dollars over the years to this endeavour, trying to follow Jesus' commandment. But, and it is a huge but, have we really followed Jesus' directions? Or are we very much alone on the labyrinth? Who is missing?

Many of our churches have built schools and hospitals all over the world. Was this enough? In our families we have tried to be faithful. We have taken our children and youth to Sunday School to learn about Christ' mission, but the Church today seems to be entering a season of failure and many are discouraged. Is it possible for the Church of Christ to fail in His mission?

One hears on the media negative comments about religion, including Christianity. Many churches are aging and few young people now attend and join. Where have we failed? Where are the problems? Something is missing. The Church, through the years,

has sent money to the poor and needy, but where have we learned how to share our Christian faith with our neighbours, friends and family? Indeed, adults tell me they feel inadequate. We expect others to teach the children, people who are trained and good at speaking about their faith, but not me. I am inadequate.

Here is the biggest problem we face when entering our Life's Labyrinth: we enter alone. We don't feel sure enough about ourselves to follow Christ's command to spread the Gospel. So, as we traverse the Labyrinth it is often a silent walk, silent in the sense that we rarely talk with our fellow travellers about our love for Christ. He rarely enters the conversation. Yet, in Matthew 28: 18 – end, Jesus says to "Go and make disciples of all nations," So this is exactly what Jesus tells us to do. We are to spread the Gospel everywhere, including within our family, our neighbours, the stranger and our work associates.

The authority to do this personal sharing is given to us by Jesus Himself. In a similar verse in Acts 1:8, we are told to start on our home turf, i.e., in Jerusalem first, then out to foreign lands. We have failed Jesus, I feel, on our home turf. We have not been spreading the teaching of Jesus in our own neighbourhood. This book hopes, with the authority of Jesus behind us, to correct this gap.

Note also that the power and the confidence to share our love for Jesus is fully ours when the Holy Spirit comes into our lives. We cannot traverse our Life's Labyrinth without Christ' power, power to do what He asks of us. His understanding and love is what the Holy Spirit gives us. But, Christ waits for an invitation

from us as we open up to His Spirit, then slowly, bit by bit, we are aware of a power going through us, telling us what to say, showing us what to do.

When people feel inadequate it suggests we are trying to walk alone, doing things our way somehow and giving in to distractions, with lots of excuses. Sadly, there is little joy and peace anywhere on that road. Have you thought of how distractions and road blocks not only stop you, but also drag you down, making you stumble over your own desires? Are you unfulfilled, restless and alone? Here is a list of possible distractions; they can become sad road blocks, tangling our footsteps along the way:

1) Family demands
2) Fear
3) Insecurity
4) Sin - guilt
5) Doubt
6) Too busy
7) Ego
8) Responsibilities
9) Church work
10) Tongue tied
11) Negative thinking
12) Religiosity
13) Secular society
14) Work hours
15) Shyness

The presence of the Holy Spirit, Jesus' Spirit active in our lives, helps us face negative influences in ways that strengthens our personality, giving us the ability to speak and share His words in love. Just ask for His help and enjoy the peace and love that floods your inner being.

So, as you enter this journey along your Life's Labyrinth, invite the Holy Spirit to enter with you. Do not walk alone for Jesus has promised to go with you. His Spirit is the Missing Link in so many sad lives. It does not have to be yours. Jesus is walking with you, His spirit is in you! All you need do is invite Jesus into your life, into all you do today.

CHAPTER TWO

OUR CHANGING WORLD

For several years now I have watched my community change around me: from casual to stressful, from friend to stranger, from personal to online, from spoken word to instant IPod. What next? What will it all come to? As we used to say: it is just a flash in the pan! It's gone already, but I am left holding the pan in horror. What have we now? Have we lost our way?

In many ways the Church universal seems to have lost its way in the corrosion of a fast changing world. In today's culture, with the instant contacts available, many people are in crisis, lost and fearful. Our future is in flux, our grand-children move quickly through our lives. Our children, the so called Baby Boomers, are too tired to reach out to those around them. What

to do? We sit in church alone and worry. Lord, what can we do?

Articles deplore that 70% of teens through to 30 year olds have left the Church and the 30% that are left prefer worshipping in a theatre free of hierarchy, where they don't have to fit in to a structure with expectations and responsibilities. Music has also changed over the years too, from classical praise to the modern beat. Lord, what are we listening to?

I think back to the period known as the Early Church, before church buildings were erected with Constantine's permission. Now that Christianity is based in a building it is very different from Jesus' custom on earth. 2000 years ago Jesus walked the streets for he had "no where to lay his head." He spent most of the day outside on the street or by the mountain side, ministering to the poor, helping the needy and teaching those who followed Him. Jesus also taught in the homes of the rich and astounded them with his free expressions. He raised the hand of the dying. Lord, we are listening today. What are you doing here and where are you ministering now?

Jesus is still among us today as He said in Matthew 28: "I am with you always, even to the end of the world." It is real, His Spirit is with us as we invite Jesus into our hearts. Yes, I am very aware that Jesus Himself is here, walking along with us through our life's confusing labyrinth. He guides and encourages us along the way, we do not walk alone. So Jesus knows what is happening today in His Church, His Body. So, is it time for another Reformation, or are we entering the period of history called 'the last times'?

Is today's instant world-wide communication part of that horrible package? We don't know. Lord.

Let's not go there to the end right now as no one really knows the future or God's intent, but let us faithfully walk along our own Life's Labyrinth with Him. He knows what is ahead and how we will change with His guidance. He gives us confidence as we trust Him. The future belongs to Him!

I pray and pray again, looking ahead with faith, but there is a sharp corner ahead. I do not know what is there, but Jesus does for he goes along with us, ahead of us, beside us, in us. Why are we fearful and discouraged? Jesus said, "Do not let your hearts be troubled and do not be afraid."(John 14: 27b)

I think the trouble with us today is that we don't really take Jesus at His word and so we are fearful of walking alone. Have we actually invited Jesus in, walking beside us, filling our souls with His peace?

I remember years ago, praying on my knees by a chair. I don't remember the scripture passage being read, but I will never forget what happened next. I felt running water, like a warm shower, envelope me, filling me, giving me a peace that I had never experienced before. This was long before I entered the ministry and was ordained. Without this knowledge of Jesus' spirit in me, filling me, I doubt I would have tackled the challenge. I was just the twentieth women to be ordained in our Church, and everywhere I went I was the first woman minister they had encountered. It wasn't easy. Yes, you Lord were there ahead of me preparing me for the road ahead

There may be a time ahead when we don't have the use of a church building, and have only house basements in which to gather, but Jesus is there in that home, with us as we worship together. Jesus is also on the street corner as we stop to talk with a neighbour or stranger about Him. We are never alone.

So, how is this world changing? First and foremost everything is known immediately world-wide through social networking and on line through the internet. This is an instant communication world, little is private, all is known by someone. Our youth love it while parents try to shut it down. This is a world that is difficult to control in one's own backyard. One does not feel safe anymore. So parents throw up their hands in despair and seniors watch sadly as their once comfortable world feels so uncontrollable. Is the earth spinning out of control?

This instant world still needs our hearts and hands to share what we really are feeling. Is it a great sadness, a wearing foreboding, or wonderment at what is new and unknown that we are feeling? No longer can people, working so hard, make it out to their community church to worship their maker. Working people or those on shift, no longer have a Sabbath rest. Slowly God has been shelved, or pushed under paper work and shift work. Now we endure a great tiredness, getting home late with a store bought supper which only puts on weight. There is hardly time to do the dishes. Where are happy parents, Lord? Are they too tired to even wonder where You went?

We need to put our foot out the door, and look around. We can still meet people, even at all hours, and share

a coffee together. But do we care? We can also meet stranger and neighbour on-line for a chat. It will not take long, after all that is the freedom we have now, just a few words here and there on-line, typed in a jiffy. But do you care?

God is going ahead of you, round every corner, up every hill, preparing the way ahead for you. The road may be rough or smooth, but you do not go alone. The Lord is still here in this culture, helping you and me to cope really well. Look now, the Lord is still ahead; just go around that corner which you fear so much. Jesus is there!

So, how do we relate personally in this instant world where even our words fly by so fast? While talking with a friend recently I learned that we need to hold on to our relationships near and far. Your friends and family are like gold, precious in the eyes of the Lord. Even teens want us there when they need to talk. Catch the need, add your love and there is the instant answer, I am here. We relate to family and friends with loving understanding, even when there is little time. We must not fear change, or fear the fast pace. Fear is far more damaging than the fast pace of our lives. Jesus is here and He needs no adapting to the fast pace of our society.

Jesus' contact with us is in our souls, and that contact is instant. Listen quietly, feel it, know the Lord is speaking to you. He may come to you as in a gentle rushing stream or speak softly in the silence. Are you listening? I am. Then I turn with understanding and tell someone I love that Jesus is still reaching out to them as He did on the streets of Israel almost

2000 years ago. You cannot miss the touch of Jesus on you; he warms your hand, or fills your soul. It goes deeper into you than anything else you have ever experienced before. It is the voice of God speaking softly in your very being.

There is something strange about our ability to turn to Jesus, to rely on Him. As long as we are strong and able to go it on our own, we keep going. So, while trying our best to serve Him we don't actually follow Him, we rush on ahead! We think we know what to do and forget to pray. Then where is He when we need Him? We are on our own. However, as I have grown weaker with age I am more aware now, more than ever before, that I need Jesus walking with me, or going ahead of me. My ability does not get in the way for I need Him. I need Jesus to reach out and hold my heart, a heart swollen and tired from high blood pressure, a heart slowing from stress and worry, a heart tired and needy.

Don't let your strength take the place of His presence. It happens only too easily in our youth, and our service years when we think we can accomplish everything on our own. We must allow Jesus in, and that takes giving in, giving up, giving all to Him. Then and only then does Jesus take over and guide and strengthen us.

Come in, dear Lord, I really do need you every day, every year, all my life. Please hold me in your hands. Dear Jesus, you are speaking to me, your follower today as in days of old. I am listening!

CHAPTER THREE

WALKING WITH CHRIST

It is puzzling to me that we go through this life believing in Jesus yet hardly ever talk about walking each day with Him beside us. This, though, is what we are contending with in this book: we are walking with Jesus along the Labyrinth of our Lives. It is His labyrinth. "Whether you turn to the left or the right, your ears will hear a voice behind you saying, this is the way; walk in it." (Isaiah 30: 21)

As a child I was fortunate to grow up in Bermuda, but I was often sick and had to stay at home feeling sorry for myself. The Manse, the Church's home for the minister and family, was next door to the church building. When I was lying on my bed I could hear the people in church singing. One afternoon the Sunday School children, meeting in the Church Hall next door, were singing the gospel song WHEN YOU WALK WITH THE LORD. I remember listening to it very carefully, wondering how I could ever obey Jesus. Obeying my parents was hard enough.

Here is the first verse:

When you walk with the Lord in the light of His word,

What a glory He sheds on our way.

While we do His good will, He abides with us still,

And with all who will trust and obey.

John H. Sammis - copy write 1921.

I joined in, singing to myself, and thus I moved close to Jesus at that early age. He has been with me ever since, walking along His Labyrinth which is my Life. Now, at a much older age, I am again wandering about that ancient hymn, this time though my thoughts revolve around how to really walk with the Lord. Well, here is an invitation to look at it differently, to see each day differently. As a believer in Jesus we do walk with the Lord along this labyrinth we call life. As the Psalmist says in Psalm 89:15. "Blessed are those who have learned to acclaim you, who walk in the light of your presence, Lord." Do we deeply and honestly affirm this to be true?

It is no wonder that the chorus to the hymn states: "Trust and obey for there is no other way to be happy in Jesus, but to trust and obey." So, through the years, I have tried to trust God with my life, but the obeying part has been a learning curve. How do we obey God`s will in today`s world? How does Jesus affect what I do and expect each day?

I understand that as believers in Jesus we are walking along our Life's Labyrinth with Him. I have never actually seen Jesus walking beside me, or even

thought about it very much, but writing this book I am thinking and praying about it now. I sense that Jesus is there walking beside me, or going ahead of me! It is a very comforting thought as being with Jesus has taken over my life.

I invite you, dear reader, to see your daily life as a walk with Jesus. Look, He is beside you. It is amazing and wonderful to personally see Jesus beside you, but in faith that is exactly what happens. Our relationship with Jesus takes on a personal tone, and we are thrilled.

One summer, while attending Bible Church Camp, the speaker told me afterwards that she had been praying silently to be able to see Jesus at camp, and know Jesus personally. Is it possible? Yes! Without this personal relationship with Jesus, through His Spirit with us today, we only believe in a bunch of words from a man that lived many years ago. Surely, Jesus' presence and death back then changed the world, but what about today? When Jesus` Spirit goes before us everything changes. We no longer worry about the next day`s plans. Jesus will see to them and bless our preparations. We relax.

It is the Holy Spirit who goes before us around every corner. It is the Spirit of Christ that walks beside us. Without His presence, Christianity is empty and void.

Do you wonder about the sacred presence beside you? Yes or No? What about right now? Do you know the presence of the Holy Spirit in your life? Is your way made clear so you can follow joyfully? Jesus is

remaining by your side, and going before you. Just trust Him always. "But I will trust in your unfailing love, my heart rejoices in your salvation. (Psalm 13: 5)

The following chapters look at many of the Sayings of Jesus. A study of these sayings will help you and others come to grips with what to do and say, how to say it and when to speak about your love for Jesus.

Reading these Scripture passages takes us back to the days when the disciples actually walked the roads of Palestine with Jesus. The sayings are actual accounts of when Jesus asked His disciples to do something for Him. As we walk today, together along our Life's Labyrinth with Him, we can listen to what He said as they did. We have many of the same hesitations, I am sure.

I invite you to see your daily life as a walk with Jesus. Look, He is beside you. It is amazing and wonderful to personally see Jesus beside you, and know His presence, but in faith that is exactly what happens. Our relationship with Jesus takes on a personal tone, and we are thrilled.

As we face this secular society all around us it is well for us to depend on the Spirit of Christ to meet us around every corner, directing the way to go. We then trust the Holy Spirit's guidance and obey His Word. This is the way we are to go. We follow and our walk through our Life's Labyrinth with Jesus is a joy. He has saved my life in many ways, from sin and yes, even from the front of a truck, and I will be eternally grateful.

CHAPTER FOUR

A MOTHER'S JOURNEY

I have heard many life stories in my years of practicing ministry, but few have been written down. It is hard, first of all, to look back with some understanding and acceptance. Most of us are hard on ourselves, right? Secondly, it takes some maturity to see that God's hand has led you and me along the journey. But if, when you try to write down your life's journey, and it unfolds in an interesting way, you may see how you have been led, and how God wants some acknowledgement now. At least, that has been my experience while walking through this labyrinth we call life. Has it been yours, or has your life been too full of pain and confusion? The hurt makes the journey hard to share.

Sally, my friend, is good with words and has some perspective, so she is able to acknowledge and share her life's journey. Sally has done a good job of following the directions Christ gave her, and acknowledges here how the Holy Spirit, the Spirit of Christ within her, has given her some spiritual perspective. Here she shares her journey. Sally first gives glory to God, who has carried her through many ups and downs.

"Glory be to the Father, and to the Son and to the Holy Ghost"! I remember singing those words many times over as I attended "The Little Church on the Prairie" Presbyterian Church as a child. Perhaps this was my introduction to the "rather mysterious" part of God known as the Holy Ghost. To be honest, as I sang those words as a child, I had no idea what or who this "Ghost" person was but I figured He must be important because we kept including Him!

Inviting Jesus into my life at 16 (thanks to a Young Life friend's encouragement) I had no idea that it was the work of the Holy Ghost (now more often called the Holy Spirit) that gave me that friend and her encouragement. At that point, I really didn't know that saying a very feeble prayer of "if you're out there, please come into my life" was the prompting of the Holy Spirit to begin a relationship with Jesus, the Savior and Son of God. All I knew was I better "try" this if I was to find out if there was a God.

Now 56 years later I understand that the Holy Spirit is that part of God who is the Facilitator. He's the One who creates environment and circumstances. He's the One who offers choice and brings us into a relationship with our Heavenly Father. He's the

Prompter, the Encourager! He creates circumstances to remind us that God loves us, and that we have "a very present help in time of need" and then He reminds us to be thankful and finally he also reminds us when we don't thank Him.

I know that it had to be the Holy Spirit who prompted me as a young Mother to begin taking our children to Sunday School, even though it meant it would be sort of a personal sacrifice to do so. Why else would I drive 6 miles into town to take our two small children to Sunday School when life to me was more about just trying to be a good wife, manage our children and have an active social life. Soon after moving to Oregon when our children were 2 and 5, it was like there was a prompting to prepare our children to know Jesus as their Savior. It seemed very evident that I had to make the choice to either give that best gift a Mother can offer, of knowing the Lord,or to leave our children's spiritual life to chance. I felt a strong urging to take my children to church---no one was telling me I should----I just felt it-- and now I realize that was the work of the Holy Spirit.

As a result of the Holy Spirit using my children to get me back through the doors of a church (Lutheran in that Oregon town and then the Alliance Church in a small Alberta town) I felt an intense desire to read the Word of God---- really!! Why, when I had tried reading the Bible before and couldn't get interested, did I all of a sudden understand the Word and couldn't get enough of it!! Where did that desire come from? It had to be the supernatural work of the Holy Spirit.

Soon I was holding ecumenical Bible Studies in our home with other young mothers. It was a wonderful time reading and discussing the Word, praying together, drinking coffee and watching our children play together.

Soon, I felt a great need to help local teens in the small Alberta farming community. I used the Young Life model and invited teenagers into our home for weekly meetings. We had guitars and drums, singing at the top of our lungs and followed by a message from me to let them know Jesus loved them. I had expected that the churched kids would come to these meetings, but instead it was the wildest kids in the high school that came. It was a huge success as they kept coming back and bringing more friends. How else would these things happen that were out of the norm for me and the community? It definitely had to be the prompting and facilitating of the Holy Spirit!

No one was telling me to do these things, motivating me strongly or urging me on with total confidence! Frankly, if someone had said I'd be doing those things I'd have said "you're crazy, but thanks for the nutty ideas!"

Years later when one of our children got in trouble with drugs I cried out to the Lord for "unusual help". The amazing circumstances that followed defy normal efforts to somehow help our son. He had to pay a penalty for his poor choices, but I know that only help from a greater Force gave our son almost immediate new directions that ultimately put him in a safe and much better place and also gave an understanding of why he got into trouble.

Most recently, I was diagnosed with cancer and I turned once again to the Lord for help. Through the work of the Holy Spirit (the great Facilitator!) there were people and places that gave unusual support and timely help----I received a feeling of peace about what needed to be done and was not afraid. The Holy Spirit facilitated people and circumstances, and then He reminded me to give MUCH THANKS to our Heavenly Father for His loving care.

All I can say is I'm very thankful to the Lord for His Holy Spirit who brought me to Christ and who has continued to give me some amazing and unusual promptings throughout my life. Perhaps it's okay to call the Holy Spirit the Facilitator, the Prompter and Ultimate Reminder so, as the hymn states: "Blessed assurance, Jesus IS mine".

CHAPTER FIVE

SPIRITUAL DISCOVERIES

Here is the number one spiritual discovery we now face as Sally discovered: we cannot successfully traverse our Life's Labyrinth without Christ's power. That is the greatest spiritual discovery ahead of us. To fully live this truth we need Jesus' understanding and love, and this is what the Holy Spirit gives us. But Christ waits for an invitation from us. He waits for us to open to His Spirit. Then slowly, bit by bit, we are aware of a power going before us, telling us what to say and showing us what to do. Note the change that is happened in you. The power and the confidence to fully live and share our love for Jesus, are obviously ours when the Holy Spirit comes into our lives.

When adults feel inadequate it suggests we are trying to walk alone, doing things our way somehow. What a shame, for the joy and peace available in the Christian's walk comes to us through the presence of Jesus Himself in our lives. In other words, the presence of the Holy Spirit, Jesus' Spirit in our lives comes not with flounce or strange behaviours, but in ways that strengthen our personality, giving us the ability to speak and share His Word in love.

As we traverse the many corners along our Life's Labyrinth we come up to a spot where we read various interesting messages from Jesus. Often they ask us to concur in some way in order to go further along

the right path. This is difficult as they ask many things of us, suggestions that demand a difficult or more personal answer. Things may look irregular, the future is unknown, or so it seems, but Jesus knows it all.

As the days stretch ahead and we stumble or race through, we tend to forget that this is a walk with Christ. We are following His footsteps. Jesus has not only gone ahead preparing the way, but also promises to walk with us. As a disciple of Jesus I walk with Him along my Life's Labyrinth. This is the first message and a vital one. (John 8:12) We are to walk with Jesus along this labyrinth. Following Him is our calling and He gives us the guidance and the opportunity to complete the labyrinth. Read again this message from the Gospel of John in Chapter 8:12. Jesus spoke to the people once more and said, "I am the light of the world. If you follow me, you won't have to walk in darkness." With Jesus you will have the light that leads to life.

The "Sayings of Jesus' discussed in this book, will help you and others come to grips with what to say, how to say it and when to speak about your love for Jesus. The Scriptures are actual accounts of Jesus' words when he asked His disciples to do something for Him. Reading Scripture takes us back to the days when the disciples actually walked the roads of Palestine with Jesus. We can listen to what Jesus said as they must have listened. I am sure they had many of the same hesitations that we feel, but look at the spiritual discoveries they have passed on to us.

With Jesus walking beside you there is power to try and power to change – just ask Him for help and go for it! I wonder if you could invite three or four other people to your house or apartment for a talk fest once a week at a time of your choosing. We are all so busy these days, time is short. However, before you know it, your age will be marked as a "senior" – careful! You don't want to drive at night, so why not have the friends come over during the day? Be flexible. There are many "Sayings of Jesus" considered here that would make great discussion material.

What if Christ turned up this morning as you got ready for the day? He may even interfere with your plans and you are perturbed. You are just trying to choose your clothes. What would be suitable? You have no idea what is round the corner. Even more dubious is what Jesus himself would be wearing today as He meets up with you on the labyrinth. Would He be dressed as a first century man or as a 21st century man? How would he stop to speak with you? How would you understand each other? What are His opening words?

We tend to think of Jesus in Palestinian, first century mode, dressed and sounding completely different from today. But, wait a moment. Jesus is speaking to you now, and you know it is Him. How do you know? There are several ways to distinguish His words from all the other speakers. There is a warm feeling inside of you as if you are listening to someone who loves you very much. Or there is a sense of surprise as things come together in a way you never considered before. Or, again, Jesus says something and it hits

dead center in your brain and you understand better than ever before. Jesus simply grabs your attention.

There will be many walls between you, I fear. Walls of shame and discouragement raise their ugly heads. Or, again, there may be walls of confusion or anger that make you shut up and not say a word. After all, you never meant to do this or that, never meant to hurt Jesus, or make Him sad. How can you make things alright again? You vow to try and reach out to Jesus, and talk politely, but to try keeping Him out of your private affairs. Right? Wrong! Your private lives, your personal beliefs, are exactly where you share truths with Jesus. There is nothing that is private from Him.

We too easily forget that Jesus' voice and His leadership speak to our inner being, in our souls. We do not literally see Jesus standing there before us, looking at us, but when He is looking at us, and we see His eyes, we see only love and compassion. So look again at Jesus' many famous sayings, printed in the Gospels. Let His meaning grab you way down deep and listen again as He loves and forgives you for all that has come between you and your Lord. There are many Sayings of Jesus that have come down to us. Think over carefully how Jesus would put it today, and pray through your understanding and response. Jesus is talking with you now. Listen carefully.

Spiritual goodwill starts filling your soul as you read and share thoughts with Jesus. This journey is filled with prayer, but it is a special kind of prayer. It is prayer that fills your soul with spiritual truths to live by. You will find your soul being enriched in a

new and fantastic way. The sharing with Jesus is so personal your soul feels alive and excited – something real is happening. You are changing. You are being filled with love. You are taking in spiritual food and it is absolutely wonderful. You have finally found your Lord and He is talking with you. This is the spiritual discovery that changes your life and affects all around you with love.

Follow on as we walk together with Jesus now as He makes several statements that make us think. During Jesus' stay on earth He made lots of comments, and at times said something that so caught the attention of His followers that they preserved them. We will be looking at several of the Sayings of Jesus over the next few chapters. One or two will surely hit home with you. Just wait and pray. Stay open! Please note these special Sayings and ask yourself: "How does this Saying of Jesus change my life and the lives of my family and friends?"

CHAPTER SIX

STARTING SMALL

Last year, while in Mexico, my friend and I helped baby turtles find their way to the ocean. They were so small in my hand, so frail. Sometimes I myself feel about that size when contemplating what life asks me to do. Where to start? Start where you are – feeling small and vulnerable. Tell Jesus how you feel and He will help.

The following "Sayings of Jesus" looked at in this book are great discussion sayings. Just think. What would Jesus say today? Listen! Share with a friend. Start relating now in today's words and manner. Send it through Facebook, or just talk quietly with a friend on the phone. What is Jesus saying to you now?

It is easy to do something for the first time when no one is watching, but how do we do what Jesus asks of us when He is with us all the time and knows us through and through? Jesus understands this feeling of basic shyness or fear of exposure. So then, how do we speak of Jesus without scaring ourselves or offending another?

When Jesus talks about our faith He suggests starting small. He knows how we are feeling - inadequate. One wonders how He started with His disciples of old. They were fishermen, uneducated, but well liked in their community. They too must have felt inadequate,

not knowing what to say. How does one follow this Master? Little did they know then what would finally happen to Jesus, but they were drawn to Him. Jesus did not come across as strong and masterful, far from it.

Jesus did not criticize people for lack of enthusiasm. He showed them how to act by His own actions. He was a man of few words, so He probably advised His followers that it was OK to feel small and inadequate. Don't be like someone who talks a lot, as if they know everything. That would put his listeners off, right? Tell another quietly, thoughtfully how you feel about Jesus.

Jesus suggests we think of the mustard seed, and of how it grows and grows when planted. Mark 4:30-32 says "What shall we say the Kingdom of God is like. Or what parable shall we use to describe it? It is like the mustard seed, which is the smallest seed in the ground. Yet, when planted, it grows and becomes the largest of all garden plants, with such big branches that the birds of the air can perch in its shade."

Mustard flowers

The mustard seed is very, very small and grows to be very, very large. Your faith can, too, if you trust the Lord to help you. So start small!

The quality that stands out in Christianity is the ability to love another unselfishly. Loving one another with Christ's love is a good place to start. How can we show

love to another and put some of this new attitude into practice? Jesus will help you, for unselfish giving in love to another is His gift to you. Don't make the mistake of thinking that He isn't beside you, He is walking there within reach, all we need do is pray to Him for help.

So, what to do first? Place hope in Jesus front and centre, and hold on. Watch your love for Him grow as you read again Christ's words in Mark 4: 30–34. Now think about someone who needs your help. Plan now how you can help. Just be sure you are giving unselfishly, with no thought of return. Share in love, but don't make a big splash. Start small.

Most seeds, big or small, sown in the soil will grow, but they need water and general care. If your faith in Jesus is the size of a mustard seed, where do you start? How do you take care of your faith?

Plant the seed first, and see it grow into something helpful. Given time, both your love and the friend's response will really strengthen as it grows. You may even see mountains being moved in someone's life. Your own faith will grow. Thank God for the faith roots in your childhood. Through the years one's faith needs nourishment: the practice of prayer, a life based on hope, sharing love for all God's creatures needs care, needs watering. What started as a mustard seed has now grown to a full plant.

Thank you Lord for the great hope we have in the truths that have been revealed to us today. We give you thanks for this evidence of your Spirit in us. We will start small and carefully.

GOING DEEPER

As we reflect on the Sayings of Jesus, a friend takes us deeper. What is Jesus saying to me, to us today?

Zechariah 4:10 says "...who despises the day of small things?" A Chinese saying says: "A thousand-mile journey begins with one step." Iris Ford says "What do we do first? Place your hope in Jesus, front and center, and hold on."

I looked up the word 'hope' in my Bible Concordance, and that little word is all through the Bible! It is said that we can live without a great many things, but we cannot live without hope. It is certainly a very strong component of faith.

Hebrews 6:19 says "...we have this hope as an anchor for the soul..."

A Bible commentator, Philip Mauro, says that the anchor referred to in Hebrews 6:19 is not the great iron weight that we are used to thinking about – that thing with the two huge flukes carried at the bow and stern of modern ships. The figure is taken from something practiced long ago in the harbors of the Mediterranean.

A massive stone, called the 'anchoria' was embedded in the ground near the water's edge. Sometimes a small ship could not make its way into the harbor by means of its sails, so a 'forerunner' would go ashore in a little boat with a line which would be made fast to the anchoria. Those on the small ship had only to "hold fast" to the line, and by patience and persistent effort, draw near to the shore.

So, if we imagine our Lord Jesus Christ as our "forerunner" who has fastened our 'rope of hope' to the 'divine anchoria' (the throne of God) we can be sure that He will bring us to where He is. This hope is as sure and steadfast as the eternal throne.

Hope also means that we are aware of a kind of divine discontent, dissatisfaction with the way things are, but there is the knowledge that Someone can be depended on to get us to somewhere better. We can develop a tough and sturdy desire to move forward and persevere in the direction the Lord wants to take us.

CHAPTER SEVEN

AS A BRANCH

As a child in Bermuda I loved to climb trees, but going too far out on a limb was dangerous. I fell often and hurt myself. So, what does Jesus mean when He calls us the branches on His tree while He is the trunk! Surely He doesn't want us to hurt ourselves. But it is clear from this well known illustration that Jesus has asked each of His followers to actually be a branch, and to always remain connected to Him.

The branches spread out with the growth of the tree, so let's focus on the way the tree spreads out, the way God's Kingdom spreads. Without Christ's followers there would be no growth of the tree. They have provided a shady rest for millions. The Old Testament, in Jeremiah 33:15 spoke of a Righteous

Branch sprouting from David's line. That Righteous Branch obviously is Jesus, He came as the Saviour of the world to fulfill that tree's mission, to reach out to the world in grace and forgiveness. Now, today, we are the branches on that tree. What a privilege to be so connected to the Lord of all, part of His growth as He reaches out into the world through us!

As a branch we must always be connected to Him or down we fall. We also need to absorb all our nutrients through the trunk, through Jesus. He is the source of everything, all spiritual food and all daily food. When a branch becomes broken and falls it dries up and dies. Could this disconnection be our problem, telling us we haven't remained personally connected to the trunk, to Jesus?

As a believer in Jesus we trust Him to hold us firmly in place regardless of how many winds of perplexity blow our way. Our basic trunk is the tree of Calvary, where Jesus gave His life for our salvation. Jesus didn't have to do that, but it was God's will, and when we hold firmly to that trunk we are held safely in place, regardless of what life throws at us. Why God chose the cross as the divine trunk to hold His son's body, I do not really know, but I sure appreciate it now. That trunk has saved my life many times over; it has brought me back from the brink many times. As a child I have held on for dear life many times. I could easily have given up without Christ to hold on to.

This truth can make a huge difference in our lives, taking away the trembling winds of change that shake us, replacing fear with strength. Prayer to God takes

away the fear of being too small and weak, replacing those feelings with faith and strength.

Look now at the marvellous branches you are a part of, growing with wonderful shade, beautiful greenery. Where are the branches pointing to? With Christ you are growing strong, reaching out to the community and country in His Name. At least, that is the image. Do you fit it?

Look around. Where does Jesus want you to branch out to? To whom can you give shade in His Name?

GOING DEEPER

Okay, so we do have to let go of a few things – like trying to run our lives on our own terms and letting other things get too important.

I remember a story about a little girl playing in a dirty mud puddle, and bawling her head off because someone wanted to take her on a trip to see the big wide ocean! It's so hard to let go of the familiar.

Iris says we have to be connected to Jesus – and that's for sure. We need each other too. I don't think we are meant to be loners on our spiritual journeys. I believe that we have to start by being very honest with God, with ourselves and with each other.

I used to have a great book (I must have lent it to somebody and never got it back.) It was called "Joan and the Whale – and other modern-day parables." I don't remember the name of the author or the publisher, but it was great skit material! It made really good points, and was hilarious as well!

One story was called, "You, sitting in the pew next to me." It was about a person's thoughts (not out loud) as she sat next to another person in a pew during a worship service. She wondered what the other person would say if she knew what a mess she'd made of some things in her life. Did she ever churn with questions or want to give up trying to sort things out? Did she really believe what the minister just said? That other person seemed so calm and unruffled. She couldn't have had to mop up spilled coffee or take the plunger to the toilet that morning...... It went on like that – and then the service was over. They both stood up. The other person said, "Lovely weather we're having, isn't it." The-not-really-thinking-out-loud person said, "It really is, isn't it!" This book peels off all kinds of pretensions!

CHAPTER EIGHT

BEARING FRUIT

 I have found Jesus to be very clear: He has appointed His followers to bear fruit. But many believers in Jesus, even after walking beside Him for many, many years, continue to feel unworthy and inadequate. What to do? How to bear fruit?

Jesus asks an awful lot - why not put off trying until a better time? And so it goes on and on – the doubt, the confusion. The attitude of pessimism would certainly affect how one bears fruit for God.

Jesus also has promised to nourish us, so why this feeling of inadequacy as we walk along with Him? There is another connection we need to foster if we are going to bear fruit for Him. The tree trunk has a daily connection which Jesus points out to be His Spirit in us today. This Spirit gives us the words to say, the action to do and the beliefs to share. Without this infilling we can do nothing. It is impossible to bear spiritual fruit for Jesus without His Spirit in us filling us and guiding us along. This indwelling can be felt, it is a power within that changes us.

The fruits that the Holy Spirit develops in us are: love, joy, peace, patience, kindness, goodness, faithfulness, gentleness and self-control. (Galatians 5:22) We are to share these with all we meet.

By the way, what would modern day grapes be like that Jesus is expecting us to grow, ripen and share with others? Today, what fruit do we offer people as we walk together along this Labyrinth we call Life? I think the greatest fruit we can produce is humility. We know we need Jesus' Spirit to do His work. Boasting about anything else is false. 2 Corinthians 12: 9 puts it clearly: "Therefore I will boast all the more gladly about my weaknesses, so that Christ's power may rest on me."

How do I boast about my weaknesses like this verse says? Now that I am in my seventies there is all too much physical weakness to drag me down, let me count the ways! But, no, I will keep this list to myself for who wants to be burdened with it? I can never actually boast about such things.

There is another verse that has been one of my favourites for many years, it also speaks of a strength that I have drawn on constantly: "I can do all things (everything) through Christ who strengthens me." (Phil. 4:13.) There is this marvellous inner and physical strengthening again.

I have been a minister for many years, but in these retirement years I wonder now if I really drew on this amazing strengthening that is available to all believers through the grace of Christ, or did I wear myself out trying real hard to get everything done. People

would say, "Ask Iris to do it, she can do anything" and I would strive to comply. Was there another way that I missed – in all humility I should have seen myself as small, and Jesus as my all in all. Doing everything through the strength given us, through Christ's Spirit is how we can all face the day ahead with hope and faith.

GOING DEEPER

I don't think that bearing fruit is something we easily do for Jesus. It is something He does through us, so it is not just a commission, but a co-mission. Somebody might say, "I don't have the personality or the salesman's ability to go out there and bear fruit. I'm totally inadequate for that!" Good! Do you ever wish you could, though?

I believe that it is in our weakest areas that God can make us strongest – that is if we have a 'want-to' (even a faint one) and tell the Lord about it.

Someone has said that "Courage is just fear that has said its prayers". If our own hearts need an operation first, we can agree to a 'spiritual enlargement'.

I believe that we have to practice this idea of partnership with Jesus until it is just what we do all the time – like breathing – and then our season of fruit bearing comes. Someone has said that the promised Presence of Christ is not a reward offered to those who obey, but rather the assurance that those commanded will be able to obey.

CHAPTER NINE

CALLED TO HELP

In Matthew 9: 9–13 we read that Jesus is in the home of one of the most hated men in His society – a tax collector. Sounds familiar? Are we mad at the government for our taxes being so high? Would we go into the home of someone we despised? Jesus wants to show mercy towards the hated, not judgment. Here is another lesson from Jesus as we walk together along our Life's Labyrinth and meet different people.

Jesus sees the tax collectors among us as sick in more ways than one. He longs to heal them. We too are called to heal the sick among us. People can be sick in their bodies, in their souls and in their spirits. People can also be sick at heart, discouraged and beaten down by their lot. Can we help them find hope?

We read in Proverbs 13:12 "that hope deferred makes the heart sick." Now Jesus offers them hope. So we are to pray that their hope for health and happiness is in Jesus Christ. This is what we are called to do: pray for them to be well in body, mind and spirit, with hope in Jesus strengthening their hearts.

Jesus is concerned for the health of sinners and wants to call the sinners to Himself through you. What is meant by the term "sinner"? It is not a word used often today. In Biblical use the word sinner refers to a person who is doing evil in God's sight as we

read in Psalm 51. This really means all of us, for all have sinned and fallen away from the glory of God's presence. This is where sin is so tragic. Sinners are lost because they have fallen away from their Creator and have no interest in the truth of their condition, cut off from God.

Jesus sees the sinner as sick, lost and cut off from wholeness of body and soul. What can you do? Their needs are great, and you as a follower of Jesus are called to help them.

GOING DEEPER

We are so enormously needy! That's the way God made us. The difference is how we go about having our needs met. If we believe that God's will is for our greatest good, then we have the greatest basic belief for a healthy spiritual life.

But uncertainty on this point led to the first sin being committed. The inference behind Satan's temptation was this: if God loved you He would not limit you like this. Satan is most effective when he persuades us to doubt that God intends the very best for us.

The Bible tells us we've all sinned. We've substituted; we've hidden the truth from ourselves and God. We've developed fears. We're afraid to let other people know us deeply. We don't come across honestly, hiding the real way we feel. But God has provided the Supreme Remedy in Jesus.

The story of the Good Samaritan shows a few 'hang-ups' that prevented supposedly good people from helping another in need. Some people live under the

fear of the threat of hell; everything they do is thus fear motivated. Also some people follow the favor thought which says to self, "God is good, you are bad, try harder!"

What about our own 'hang-ups'? Grace may flow like a river, but a grudge (or a fear) will dam the stream. Our Great High Priest, Jesus, is a wounded healer. He experienced all kinds of human suffering. The Bible says that Jesus was 'a man of sorrows, and familiar with grief.'

Somehow we are most able to help others in the very places where we have been wounded. We know something of the pain and are better able to respond in those places. We have a fellow feeling. Instead of resignation, resistance or resentment in times of suffering, we may be able to see more meaning in those times.

There is a story of a Deacon whose character was impeccable. All the qualities of the fruit of the Spirit seemed to flow from him. One day his minister asked him how he was able to demonstrate the character of Christ in every situation. At first he was reluctant to open up, but when he did he shook the minister to the core. His father had been a drunken brute who, every Saturday night would come home from a bout of drinking with his friends, and throw the family out of the house, forcing them to spend the night with neighbors. Later in life, after this man became a Christian, he suffered a series of disasters such as one could hardly imagine. Yet, this is what he had to say: "God has given me grace in every situation, grace that enabled me to more than cope with everything –

grace not only to deal with the situation but to rejoice in it."

Paul, who was so good at spreading the Gospel, seemed to focus on his reward waiting for him, as he wrote to the Christians in Ephesus: "...doing the will of God from your heart. Serve wholeheartedly... because you know that the Lord will reward everyone for whatever good he does."

Some see it like this: "Ah! Trouble, how it chisels and carves and shapes and moulds the soul."

Somehow, we have to allow God to free the flow of grace in us so that we fulfill our calling to help those in need.

CHAPTER TEN

SALT ANYONE?

Are you on a salt free diet like so many people today? We have been cooking with too much salt, right? How can Jesus tell us then to be as salt to another? What did He mean, and how does it apply to us today? Teachers and professors are worried about the physical deterioration of teens, for they are showing signs of stress.

Our lives are like salt flowing out constantly, but we have no seasoning that really counts. What we have is too much food, too much sitting, to much computing, too much of everything!

Back in Jesus' day there were no refrigerators so salt was very valuable as a preservative. Today, as Jesus walks beside us He gives us a bit of a puzzle: He says we should be as salt for those around us. How can we be a preservative in another's life, when we are too salty ourselves?

Salt is also a detoxifier for a wound. How are we to apply this symbol as we walk with Christ? How can we help others who are suffering, or have nothing to

flavour their long and boring days? What if a person is wounded deep in their souls?

In Matthew 5:13 we read Jesus' words about salt. Clearly we are to be as salt in another's life. Put yourself among the first group of disciples with Jesus, and listen as if He is speaking just to you today. What He said back then must be relevant to your situation today. Be as the salt of the earth for another as Jesus was. Have I ever been a good seasoning in someone's life, or be as salt in a person's wounded heart? Where have I been like salt in a person's life?

Take your concerns and fears to Christ Jesus, He will understand. He will strengthen and uphold you. He, through His Spirit, will speak to another through you. Jesus will suggest in what ways you can be of help to a hurting soul.

It's time to be honest here about your life. You have struggles and problems that confuse you. Why not take your struggles to Christ in prayer, asking for directions on where to go from here. Maybe walking through life with Jesus beside you is too difficult. He makes you look at yourself, maybe for the first time, without wavering. He sees you! How will you deal with it? Ask Jesus for help. He truly sees you in love, and will answer your prayer, but perhaps in a surprising way.

GOING DEEPER

Here are two honest questions. What is our calling, and what is effective salt? We influence others more by what we are than by what we say. Are we salted?

What are we called to do? We cannot help others until we have allowed God to help us. The deepest influence may be in some unwrought movement of Christ in us, of which we are completely unconscious. What we truly are in ourselves comes out eventually.

Words are powerful only as they come from the inward life of the Spirit. Therefore our work in this world is to be salt and light that Jesus says we are (not as we should or must be.)

We are to be the only salt to hinder the world's corruption. A small minority of believers can penetrate (like a tiny bit of salt in a lump of dough), giving new savour to life around us, and holding back the sweep of evil.

We are meant to give the whole counsel of God (not just the 'feel good' bits), whether it is fashionable to do so or not. Salt hurts sometimes, but it also heals.

Are we willing to move into the secular world with salt to hold back wrong, and to bring more meaning to life – to bring healing to those who are caught up in a disintegrating whirl?

When we speak up for the truth, or forgive instead of taking revenge; when we choose to openly trust in God, when those around us are in a tizzy are we then salting the situations with Christ?

Salt may be invisible when dissolved in things, but it is surely powerful!

CHAPTER ELEVEN

A LIGHT PLEASE

Years ago, while in Bermuda, my friends and I descended deep down into the Crystal Caves. I was scared and wanted a light to hold, and be real quick about it. The darkness made shadows all around and they were awesome. What was I really looking at? Were they stalagmites and stalactites, or something more sinister? I didn't know.

People living in Northern Canada are used to more than half the year spent in darkness, but here we are used to electric light whenever we need it. We rarely walk in darkness as Jesus and his followers did years ago. They only had candles and lamps. We have car lights, street lights and lights in our house in every room.

Yes, Jesus knew there was very real danger in darkness, especially the kind of darkness caused by trying to go through life without Him. Jesus called Himself the light of the world. (John 8:12) He has brought true light into our lives, illuminating the inner spiritual darkness so we can find our way home, home to our Lord and God.

A way to describe darkness is to see it as void of light. In the same way spiritual darkness is a life void of God. People who don't know Jesus as their Saviour are in spiritual darkness, they don't know

that God loves them. These folk need to free their souls from spiritual darkness through the work of the Holy Spirit, or the Spirit of Jesus himself coming in to them. Then the light goes on!

We all need to follow Jesus' request that we be a light in another's life. (Matthew 5:14-16) This wonderful light makes us all aware of our spiritual condition. Ask yourself now some deep searching questions as you walk together with Christ along your Life's Labyrinth. Do you live in darkness? Does your soul feel lost, not able to see anything that goes real deep?

We light up another's life by telling them about Jesus, what He has done for us, and how much we love Him. Jesus will show us how to speak and share our faith. Just trust Him to help you. Ask Jesus how you can experience Him as a light in your life. Then, as you share, maybe you can see how Jesus is a light in someone else's life. Your words were as a light to your friend.

Jesus said in John 8:12 that if we walk with Him along our Life's Labyrinth we will never walk in darkness, but will have the light of life. That means we will live as an example for others, as a light, shining as we walk along together. A Christian never walks in darkness. Wow!

Thank God for Jesus in whose light your life is enriched and guided. Now do you know, and can you share, how Jesus actually is a light in your life? But, it is ever so sad when people hide the light in their lives. What have we used to hide Christ's life under? Could it be looking for sympathy under stories of your bad health, or are you simply too busy to share? Could it be your timid personality, unable to share anything you are not absolutely sure of? Have you not learned to trust the Holy Spirit to give you the words to say, and the circumstances? Try Him. He is just waiting for an opportunity to shine in you.

GOING DEEPER

Our outer eyes need light to see. We get light from the sun, from electric and battery sources, from the moon and stars, from candles and lamps of different kinds. In I John 1:5 we read that God is Light. Later we note that Jesus also said, "I am the light of the world." (John 8:12) And again He surprised his disciples by telling them; "You are the light of the world." (Matthew 5:14) How are we the light of the world?

The following verses reveal truths to ponder on and meditate. The first thing God made was light and thus He made an expression of Himself. The essence of God's being was streamed into a dark, formless chaos – and it was good and beneficial.

God revealed Himself to His people in visible light, e.g., as a pillar of fire, in a shining cloud, leading them out of Egypt. It was brilliant light, awe-inspiring, beautiful and holy.

Now look at the account of the Transfiguration of Jesus in Matthew 17:5. Look up also what happened on the road to Damascus in Acts 9:30.

Now read in Psalm 104:2 that God "wraps Himself in light as with a garment:" Does this mean absolute holiness and moral perfection? Now sadly look up John 3:19: "Fallen humanity loved darkness more than light because their deeds were evil."

Finally, Revelation talks about a renewed earth where God and the Lamb of God will be the Light, and we won't need any other source.

We give out light in proportion to how we stay open to Christ's Light. If we turn our backs to light, we only see shadows. (Ephesians 4: 18-24). We are called to go into places of darkness, to dark troubled hearts, to lighten a lost, closed soul.

Each of us is called out of ourselves with Christ's light. Yet each person has to choose to let the Spirit move in them. We all need to receive Christ Jesus; the Light of the World, and then His light shows up former darkness, and a new way of life can begin. People suddenly see what they couldn't understand or appreciate before. It is God's complete re-orientation in a person's life.

CHAPTER TWELVE

THE STRANGER AMONG US

After shopping in the local grocery store, my friend and I tried to climb into our car, but we were parked too close to the next car making it impossible for me to get my foot up from under our door and into the car. What to do? Then a lady, a total stranger, bent down and lifted my foot in. Sure I was a handicapped senior, but she didn't have to do it. Her action touched me. A stranger's hands reached out to help my foot, and it reached my soul.

What can we do to help a stranger as we walk along together on this journey? When Christ walks with us along our Life's Labyrinth, He puts many strangers beside us. Christ also reminds us, as He taught in Matthew 25: 43-46, to help one another, whether a stranger or a friend. A stranger, though, takes a bit more thought, or does it? Will we, in Christ's love, tuck in the stranger's foot?

In this modern western society most of us live among strangers, few of us are near family or old friends. There are many occasions where we should obey Christ's command to help the stranger. Do we measure up? There is something special about showing mercy to a stranger, but there is also some fear for we do not know the stranger. There is danger.

Today, when you and I act toward a stranger with love, out of compassion,we are acting in mercy. I wonder how many times we act on behalf of another, and never want a return favour?

Jesus taught us, as his followers, to act out of mercy, not greed. So, what is mercy? It isn't a word in use today, so what does it really mean? When 'mercy' is used for the Eternal God, "ever merciful, ever sure," it refers to God's steadfast love. When Jesus' disciples used mercy it meant acting with God's loving understanding, sharing with compassion. There would be no expectation of a return. Such an unselfish act is done in mercy.

So, do we understand what Jesus meant by showing mercy to the stranger? If mercy means using a freely given, an unrequited helping hand, there is no need or opportunity for pay back, there only is the recognition of love shared.

The stranger then is someone in whom we see Christ suffering also, and in helping the stranger we are also helping Christ. In this acknowledgement we give all we can to help the stranger in need.

Do you know the story of the Good Samaritan in Luke 10: 13, 25 - 32? The media paints a heroic picture of such a person, usually acting the partial fool, thoughtlessly pitching in to help. Without any thought of personal safety, reaching out to help a stranger in need, he or she often gives all, only to lose his or her own life. Is this what Christ requires of us when we go to help the stranger among us. It is a serious question that takes much reflection, after all.

Have you helped someone in need this week? Did you previously know that person, or was it a stranger? Here in Canada it can be dangerous to help a stranger, he or she might turn on you. What to do? It takes much prayer to follow Jesus' instruction to feed the stranger, (Matthew 25: 35), but this is what we must do. Look at the children in third world countries who are starving or dying without an adult around to feed them. Their pain is Jesus' pain.

In reaching out to help someone, as Jesus instructed all of us, you thought you were helping a stranger; actually you were helping Jesus, doing it in Christ's Name. He would be there protecting you, filling you with love to share. You are helping Jesus when you feed the hungry, or give someone a cup of tea. One never really knows our motives, but the purist motive of all is something done in love, without any hope of a return. Have you felt that inward sense of being in Jesus' arms? You are happy? You are content with your actions?

Christ gave His all on the cross to help a world full of strangers. The difference is that God's grace is wonderfully efficient, it goes the second mile. Do we? Or do we take the road less travelled these days, put up our tools and look away when crossing the street to avoid the stranger lying on the curb. Jesus himself is the stranger among us all too often. Do you see Him?

I look at the cost to myself for the sharing of my time, having less now of my goods, taking away from family meals, to be shared with a person in need. It is an act of mercy that grandma often did, but we rarely do. I wonder why. What is Jesus saying?

GOING DEEPER

When it came to church I felt like a stranger many times. When I stayed away no one ever asked about me or called me. Their lack of real caring hardened my heart against the Lord. I questioned if He really cared about me, although somehow I don't think I ever stopped believing in Him. I also wondered that, if He was such a good God, how could He let all those bad things happen? I became angry with God.

Even when I ended up in hospital with severe depression for extended periods of time, my best friend, a Christian, didn't come to visit me. She has never called or visited me since I moved to Parksville. Even when the Minister of our church came to see me, I felt he had to come, or so it seemed to me. I might as well have been a stranger, I sure felt like one.

When I followed my parents to Parksville I stopped going to church completely, partly because I was single and didn't fit in. I felt I was only tolerated because of my parents and not for myself. I was always lumped in with my parents. Being single I was always the odd person out and never felt truly welcome.

Most of my friends in Parksville were not Christians and they didn't want anything to do with God. I struggled along, alone. My friends and my parents were getting older, and I started to think about ending up all alone. I couldn't count on my brothers either, so I felt really afraid. Then my mother died and reality was starting to set in. I found I had to do something. In hindsight I wondered if this was the Spirit talking to me.

One day, while visiting my father, dad's Pastor dropped in to visit him. While there, he asked me how I was doing and if he could do anything for me. This was a first in a long time that a stranger had shown concern about me. We received the same caring from dad's elder, and the congregation at the memorial service for my mother was supportive and friendly.

All that got me thinking: was this the Spirit planting a seed again? I needed to find a community where I could belong. Surely there is no better place anywhere than Jesus and His Church. While I still worry about my future, I have found a home. I feel welcome here and am becoming involved. This is my spiritual home. I feel the Spirit has touched me, saying "come."

CHAPTER THIRTEEN

A CUP OF COLD WATER

Giving a cup of cold water to someone in need is an easy saying, right? But, sometimes when I read Jesus' ancient sayings, I feel as if there are several meanings. What did Jesus really mean by 'water'? What did He mean by 'cold'? Neither word refers to how we see 'cold water' today. All we need do now is pour a cup of water with an ice cube in it, taken out of the ice tray. But Jesus always taught a lesson, a spiritual lesson that usually had a deep meaning. An important truth is hidden in the cup of cold water, a truth about God's gift of salvation.

One day Jesus gathered His twelve disciples and gave them certain instructions for their visits to some neighbouring communities. This saying, about a cup of cold water, is in those instructions. As Matthew 10:42 reads; "And if anyone gives even a cup of cold water to one of these little ones because he is my disciple I tell you the truth he will not lose his reward."

Do we have little ones around us? Does Jesus mean in age or in faith? Who were they? Could Jesus have been referring to us?

That day the disciples must have felt unworthy and ignorant as they went out, sharing the words of Jesus with people in another village. They felt small. They

also got very thirsty, for Palestine is and was a hot climate. As they shared they would be aware that all the water was precious in that land, as were the neighbour's children. So does this reference to little ones have a hidden meaning? Who was Jesus referring to? It could be us.

Then what did the water mean, why did Jesus refer to a common element of life? One meaning for water is found in Isaiah 11:9 where water referred to the knowledge of God: "The earth will be full of the knowledge of God as the waters cover the sea." Water could also refer to salvation, as in Isaiah 12: 2, 3 we read: "With joy shall you draw water out of the well of salvation."

The third level of meaning for water is found is John 4: 13, 14: "The water I shall give him shall be in him a well of water springing up with everlasting life." This understanding of water refers to the Holy Spirit, springing up within us into new life – everlasting life.

So, water refers to the knowledge of God, salvation of God and the inner life of the Spirit of Christ. Wow! It is no wonder that we search for meaning. We all need to drink of the water Christ gives us.

Now, let us look at the temperature of the water - cold water. I think Jesus was implying that the water He gives comes from a deep, cool well, from the very heart of God. We are receiving from Jesus a truly refreshing drink – from the deep, deep love of Jesus. This water refers to everything Jesus came to give us.

I wonder how many of Jesus' disciples were aware of the deep truth of this saying.

What do we really offer a friend to drink when we share a meal, or give a street person a drink of cold water? Do we offer to them, in Jesus name, the water of life, telling them of Jesus' mission, coming to earth to bring us God's salvation? Do we ourselves know what it is to be filled with the Spirit of Jesus refreshing our spirits every day? Have we drunk of His spirit of love and sacrifice?

"Jesus answered …but whoever drinks the water I give him will never thirst again. Indeed, the water I give him will become in him a spring of water, welling up to eternal life." John 4: 13,14.

GOING DEEPER

I wonder if I would be included in Jesus' comment: "These little ones"? Who did Jesus mean in this reference? It looks like He meant His disciples – the twelve. This was their first town to town visit in His Name. Jesus sure didn't think very highly of them,

eh? Were they ready to be sent out two by two into the vast world? What would happen to them?

Did Jesus mean men who were little in faith and the ways of God? Does little in faith mean having a lot to learn about following Jesus' instructions?

Reading over this Chapter 10 of Matthew makes me realize that Jesus knew what was coming when He left them, He details it here in rather strong language, and was fearful for their well being for they were like little children.

I wonder about the youth of today. Do they know what is ahead? Do any of us know what is to come as we walk along our Life's Labyrinth with Jesus? No, we don't but Jesus does. We trust Him completely or we cannot get safely to the end.

CHAPTER FOURTEEN

MORE THAN SPARROWS

Jesus said: "But even the very hairs of your head are numbered. Fear not therefore: you are of more value than many sparrows." Luke 12: 6–9. What did Jesus mean by this reference to sparrows? How would He have put it today?

Here in Canada the sparrow's return reminds us that summer is coming. I enjoy seeing them hop around while I walk in the sunshine. Jesus referred to sparrows several times. Sparrows are very valuable as a lovely part of God's creation and we are even more important than those birds. To a bird lover that is important assurance: we are valuable to some one – God. But do I feel very valuable? In Matthew 10:29 Jesus referred to two sparrows as real cheap, just a penny, but not one of them will fall to the ground without God, our Father, knowing it.

Sparrows were the cheapest bird for sale in Jesus' day, but, according to Jesus I am more valuable than that at least. So why do I feel so small and insignificant? But wait. What about counting all my hairs? I have curly hair, real curly down to their roots, hundreds of them.. It would be very hard to count all my hair, yet Jesus uses this curly top as an expression of caring - caring for every hair! Is Jesus going too far here? Does God count all of me as valuable? Yes! I am more valuable than many sparrows. Wow!

I often wake feeling as small as the sparrow, insignificant – just a senior. Woe to me - I am now a senior! I have many aches and pains, and my drawer is full of pill bottles. Is there anything about me that God cherishes? Well, enough of my friends in church say I have a good grasp of words for preaching and writing. I have written several books. Is that what God considers as valuable – what I have accomplished?

Our Heavenly Father notes our works, but what really counts here is His love for us. Each one of us is cherished by God! He watches over our every move, our every deed. Even when we are so small, and seemingly insignificant, there is wonderful assurance for all who believe in Him.

Fear not therefore, and trust in God. Want of faith is the problem with us small creatures. We need to believe in Jesus' teaching that God has undertaken to save and defend all who trust in Him. We can go through life knowing that we are all greatly loved and cherished by the Almighty. Indeed, the Lord goes with us, protecting us from a worse calamity when we fail. The Lord notes our need. We are real small creatures in His great creation, but He is there beside us, carrying us when necessary.

Each of us is very small, and not very important, but what a God we all have! All we need know is that we can utterly trust Him in all we do today. He takes notice when we fall. Even though we are such small and insignificant creatures, God sent His Son to save us. We are of more value than sparrows. We can believe that. It is true.

You can be sure you are not forgotten by the Lord, your God. You may be imprisoned, forgotten by your friends, banished, or much more. Still, you are not ever forgotten by God. You may feel depressed and alone, not loved by anyone, with all your family elsewhere, but you are not really alone, even in death. Scripture says that even more precious in the sight of the Lord is the death of His saints, yes, even more precious than the death of sparrows!

The History of the Early Church, through the first 300 years of Roman times, indicates 300 years of trials and turmoil. Many died from being thrown to the lions or from spending years in prison, but they were not forgotten by God. Their faith stood the test, and by the year 300AD Constantine declared Christianity the religion of Rome.

Today, we also face times of confusion and neglect. There could be trials and temptations coming our way. Also, the youth of today are not interested in attending church. No religion is respected; they do not even believe that God exists. Few experience His love and how many understand an act of worship? This is an age of parental disconnect. Too often fathers leave the home, and mothers are tired out from work and family circumstances. There is no time for the worship of God.

Yet, through all this new age, when sermons seem irrelevant and worship is seen as out of date, and web surfers everywhere communicate in seconds world-wide, how does Jesus speak today? How will His disciples – you and I, speak today? Are we worthless too, or are we of more value than sparrows? How do

you share your faith today in this secular age? How will you tell your child, or grandchildren, that they are valuable to God? Will they understand when you tell them that they are more valuable than a sparrow? That even the very hairs on their heads are numbered and known to the Lord? Would they understand better if you said that all their tears and fears are noted and acclaimed as an offering to the Lord? But, you are told: they don't talk that way! Then how will Jesus speak to them today? He is talking to them, you know.

GOING DEEPER

I have felt like a little sparrow most of my life, totally insignificant and inadequate. I don't know what happened when I was little, but as time went on it always seemed I couldn't live up to my mother's expectations. Adding to that was that my mother

always considered my brothers more important. I was only a girl! Even my dad didn't believe I was capable. It seemed to me I should be perfect and I wasn't.

There were a few times that I felt important. Like the time when I became the expert at Word Processing (this was before computers) at work – I was capable of something!

Then I went back to school and the expectations I put on myself were impossible, and I turned to alcohol. The longer it went on the worse I felt about myself as a total failure, but finally I once again started to feel better about myself when I sobered up. This landed me a job as church secretary in my home town, and once again I felt important and wanted, thinking I could be of value to God and His people.

That, however, just lasted four years. My expectations of the job were different from the Pastor's, and I once again felt I was a failure. As a result, I quit my job. I ended up in hospital depressed again, and I didn't want to live any longer. In my eyes I was even less valuable than a sparrow.

This period of my life lasted a long time but over the last couple of years my circumstances have changed and I started feeling better, but still something was missing. I still felt totally inadequate and insignificant.

When my mother died my dad and family relied on me for support. I was also re-introduced to the church. I wanted to belong, but I still continued to question and doubt myself. I still felt like that little sparrow, but I believe God was planting a new seed.

I have become involved and have been thoroughly touched by the Spirit.

Am I valuable in God's eyes? I would like to believe I am. Can He use me? I truly believe that it's now my turn to spread Jesus' love. How do I do that? By being honest about my life and sharing the ups and downs with people.

I have not been given the gifts of eloquent speaking or writing. Also, I am not good at talking about my renewed faith, partly because while I grew up in the church we never talked about God. Even our prayer at the family table was nothing but going through the motions. Another reason I have difficulty is that my non-Christian friends don't want to hear about it. I still find sharing makes me feel inadequate and uncomfortable.

I believe I do have one gift and that is that I can show my faith through helping people, or being there for them whether they be family, friends or strangers. I honestly believe that the Spirit uses me and works through me to show Jesus' love.

CHAPTER FIFTEEN

WHAT WOULD JESUS SAY TODAY?

In looking over these Sayings of Jesus, printed in this book, I am wondering how they were repeated and used as the years went by. After Jesus left them to return to Heaven and His Father's side, how were they recorded? How were they shared and used during the period of the Early Church? Christians, during the Roman Empire were persecuted, imprisoned and killed. To share even the name of Jesus was dangerous. A FISH was the secret sign that Christians were in this house or that catacomb, meeting in secret. They were fearful years, yet the Church grew.

Through the Gospels and letters written in the early Church period the letter to the Corinthians is the earliest. However, 1 Corinthians 9: 22, 23 can be an irritation to me. "To the weak I became weak to win the weak. I have become all things to all men so that by all possible means I might save some." Did Jesus indicate to His followers that we should be all things to all people in order to catch their attention? People tend to be more receptive when the message is from someone in whose company they are comfortable. You don't get through to someone if you think of yourself as much better than they are.

How do we become weak to win those who are weak? How did the early disciples? This is an interesting proposition. As we walk along our Life's Labyrinth

today we either walk as if we own everything or we walk humbly. How do others see us, weak or strong? Do we walk as if we are all equal? How do you walk?

After my operation for a hip replacement years ago I spent a lot of time on the couch for obvious reasons. As people visited me, during my recovery, I felt closer to them than at any time I was in the pulpit. I was weak and lying down! When we are weak it leaves room for Christ to reach out to another who is also in need. Are we not all in need at some time or other? When someone meets us at the point of our need, God moves in with His love and blessing. In our need we meet Him and each other. Wonderful!

Paul, a leading believer in Jesus in the early church years, was bemoaning his weaknesses one day. He admitted that it was his inabilities that God used to reach out to an unbeliever. Paul didn't need to pretend to be strong for God could use him just as he was. He became weak to win the weak. (I Corinthians 9:22) We read that Paul had a thorn in his flesh, but no one can describe what really was wrong.

Never set yourself up so strong that you don't need anyone's help. God reaches out to the weak for their need of Him leaves an opening for the Spirit to enter. When we try to reach out to another person with the message of Jesus it is best to start from a common perspective. It is on familiar ground that we can both be at ease, where we can make contact for the Lord.

You don't have to be great! You don't have to be all knowing! Just be yourself and let Jesus use you as you are: weak, yet game.

GOING DEEPER

How do others see you, as weak or strong? How do you see yourself? You are more likely to seek Jesus' help if you see yourself as weak and inadequate. Others also may listen to you better if you don't come across as a "know it all".

Yet, how does a leader, perceived as weak, lead others to know Jesus? They might come across as not worth listening to. Ouch. You don't want that! So what do you do? Well, consider this: how do you really see yourself: as weak and inadequate, or strong because you have a strong faith in Jesus? If it is the second: a strong faith in Jesus, your belief will show as a light within you, a sparkle in your eyes. Others will listen to you for they are curious about that light. Where does it come from, this sparkle within you?

Do you agree that God has created us weak so we are dependent on Him in all things? In the unfortunate situation among the early Christians, when there were many killed and persecuted before things got easier under Constantine, they were totally dependent on their Lord Jesus Christ. But what about today? Do Christians need to be weak today to become aware of their need for God? In what ways do you depend on the Lord? What is Jesus saying to you here?

May I suggest that you take another look at all the Sayings of Jesus included in this book? How would Jesus speak to you today? It would be helpful to memorize the Sayings that went deep in your soul. Take two or three Sayings and repeat them to yourself every morning, and repeat them also off and on through the day. Start living the Sayings' truth in

your daily life, placing them into what you think and what you do, so that they take over your day. Let each one go deep into your soul, and Jesus Christ will see them take root. I can guarantee they will change your life. That is why the Sayings of Jesus have lasted and lasted, heard by millions to this day. Each one has borne much fruit.

Why not invite a few friends and neighbours to your place to discuss this book, and especially the Sayings of Jesus. As you pray about your choices, the Sayings of Jesus will speak to you in words that reflect today's world. Ask yourself – "how would Jesus speak to my generation today?" Why not rewrite the Sayings of Jesus in a new way to be understood by all, especially the children, youth and young adults of your day. I would love to hear what you think, so could you contact me through my publisher or on Facebook, sharing your thoughts of each Saying of Jesus. I would love to hear from you!.

You will be amazed how the Spirit of Jesus informs your inner thoughts; His words will fit so well into various situations today. Look back over the Sayings of Jesus given here, and reflect again on the one or two that really hit home with you. What is Jesus saying to you now? Will Jesus speak to your soul in such a way that your life will be a reflection?

CHAPTER SIXTEEN

MATURING IN FAITH

As we age we tend to look ahead and act according to our past accomplishments. It is hard to be new and different. So, how do we see ourselves – grown up at last? Grown old too soon? If one feels weak and inadequate, or inexperienced and childlike, we haven't matured very much. SIGH. Do we feel that others have so much more to contribute? Many adults, and/or seniors, rarely enjoy a walk along their Life's Labyrinth, even with Jesus; people are too tired, and feeling exposed and inadequate. So, how do you and I really see our life's walk along this Labyrinth? Let's be honest here. Have we really matured in the Christian faith?

After Jesus left the earth, at the Ascension, the disciples must have felt very lost, inadequate and fearful. As the days passed, Peter and the others would have repeated the Sayings of Jesus over and over, and wondered how to follow their Lord's requests. Over the years Peter, Paul and others went forward in faith, never doubting, even when they were crucified, as Peter was, upside down. Peter did not want to be compared with his Lord's crucifixion.

Let's look now at a Saying of Jesus as recorded later by Paul, writing to the Corinthians in 1 Corinthians 3:7-9. "Neither he who plants nor he who waters is anything, but only God who makes it grow." It must

have been evident that the planting and growing in those early days, depended totally upon God. Progress was crucially important to all the disciples who were left behind that day, when Jesus returned to Heaven. Eventually many died by crucifixion themselves, but Paul knew that only God could take what was done for Jesus and make it grow. This promise is also important to all of us living in the twenty-first century.

The Lord has assigned each of us a task; we only have to look to Jesus for the knowledge and the strength to accomplish it. Do you know what Jesus is calling you to do? It takes trust to follow Jesus, but we grow as we trust Him. It is through the trials and hardships of life that we grow the most. It is through our pain that we share the most with others.

Around every corner of your Life's Labyrinth there is a surprise you didn't know was coming. As Christ accosts us along the way He shows us more of ourselves by introducing us to the most valuable lesson of all – the power of the Holy Spirit in us. It costs us much honesty though. Sometimes we like what we see and sometimes we are ashamed. Jesus sees right through us, yet His Spirit is comforting and encouraging. He tells us: "God will help you grow". You are God's field, in which wonderful spiritual plants are growing. Look again at I Corinthians 3: 7 – 9: "For we are God's fellow workers; you are God's field. God's building." Wow! What a job lay ahead of those early disciples.

Which of the truths in this passage reaches you? How does it make you feel to be told that you are God's

field, or even God's building? Do you feel as if you are God's fellow worker? Are you a recipient of God's seed? He expects a lot of His followers. But God is making you grow. "But, how," you cry! Yes, we all need to grow in faith.

God has not left us without help. There is power to change and grow available. Jesus knew how his disciples were feeling when he left them. His whole mission to earth was at stake. What to do? There was a wonderful plan already in place. God sent His Holy Spirit to empower Jesus' followers. What was this power like?

Acts 1: 8 is a marvellous passage for all of us today: "But you will receive power when the Holy Spirit comes on you," but be careful how you read the word 'power'. In these secular days power means many things. You can use the word to refer to being strong and courageous, or as the power to rule over other people, or to just get things done your way. Money also is power! You can have a lot of strength in your decisions, or you can persuade people of your plans because you have the money to follow through. Those plans can refer to being in a power position as in politics, or with a scientist who can read the stars or the future. Rarely does it refer to the likes of us poor, unsteady people! Or does that position offend you? How do you see yourself on the power grid?

Power, however, is promised by our Lord Jesus to His followers in Acts 1:8. What really does Jesus mean by this power? Jesus is actually talking about His own Spirit, the Holy Spirit, which will come to us when we ask. It is really unselfish power! It is not to get our

will done, as many think. It is power to live for Jesus and to follow Him faithfully, doing what He asks of us. It is God's power within us as His Spirit dwells in our spirits and makes us wholly His.

Jesus has given us a job to do, and gives us also the power to do it, but do we understand that gift? The Spirit of Jesus gives us the ability to love unselfishly, to give to others when we go without, to heal and to soothe. It is a wonderful power, full of the love of God. Best of all, one can tell when Jesus wants something of us as there is an awakening inside, a feeling, even a trembling, for something in us is changing. Plans change overnight, decisions are made with excitement, people come onboard unbidden.

Something strange is going on. We are filled with a power one cannot control, but it is wonderful. The power that is Jesus' Spirit within is the power of love and life. And just watch things in your life come alive. This is the power that matured the Christian's faith beyond all else. It is not just knowledge, even though all knowledge is of God. It doesn't just reveal the words of Scripture; rather it is the words of Jesus, alight with life. It is power, God's power, going with you each day as you traverse your Life's Labyrinth with the Lord. You cannot be a fully mature follower of Jesus without His power. All one has to do is ask for His power to come to you, and He will.

The most essential power of all is the power to give of ourselves to others as Jesus did. We give in Jesus' name, and in so doing bring into the situation blessings that go way beyond our greatest thoughts, our greatest gifts.

In Ephesians 1: 13, 14 we read that the Holy Spirit is a "seal" bonding us to God and to Christ forever. Nothing we can do will break that seal. This truth gives us the confidence to change the way we go about our service in Christ's Name. It gives us the power to do what Jesus wants us to do.

The power Christ freely gives us, in order to serve Him, is sealing us to Him forever, and it is given in great love. What a wonderful gift! In the early disciples and in us today, it can and does change the world for Christ. Thus we fulfill Christ's mission to earth all these years later. Now, rejoice, for we have matured in faith! In Philippians 3: 14 we read: "Forgetting what is behind and straining toward what is ahead, I press on towards the goal to win the prize for which God has called me heavenward in Christ Jesus."

CHAPTER SEVENTEEN

WHO HAS THE END WORD?

We have been listening to Jesus, and trying to understand His famous sayings for some weeks now, but who has the end word? Does Jesus have it? Are we called home to Heaven by Jesus himself or does our body just give up? How often did Jesus speak of death and how do we picture it? Is Heaven our real and final home?

I am just starting to read a book on heaven, HEAVEN IS FOR REAL, written by the father of a boy who came back "from heaven". Is Heaven real, or are our hopes mixed up with our dreams? I have heard Heaven described as the real thing and earth is but a shadow. I have heard Heaven described as another dimension of life where all our favourite things hang out – our dog, our famous tree, our friends and family. Can all this be true?

Is heaven nothing more than all our hopes redeemed? Do we hold on to this wonderful idea fulfilled and that promise restored, and picture it all as Heaven? However, when people give up all talk of heaven, still the hope remains, though rarely talked about. What is our end place anyway? When few read the Bible anymore how will we talk about Heaven today, for the Bible is the last word on Heaven, isn't it? Who has the last word? Is it the Bible, or our hopes and

dreams? I vote for the Bible, so let's look it all up, every verse that we can find.

There are twenty-four verses listed in THE OXFORD CONCISE CONCORDANCE for heaven. We do not want to look at all of them here. I will just pick out the clearest and most important for now, starting with Genesis.

The book of Genesis presents heaven as part of God's creation, for God created the heavens and the earth. (Genesis 1: 8-14) We have long spoken of heaven as the sky above and looked up to the blue yonder for inspiration. Elijah was taken up to heaven by a whirlwind, (2 Kings 2:1) but, does anyone want to leave this earth by a whirlwind? I doubt it.

The Lord's throne is in heaven (Psalm 11:4) and there is the beautiful reference to heaven in Psalm 139:8 "If I ascend into heaven thou art there." Is anything interesting you yet? How about this from Isaiah 65:17 "Behold I will create a new heavens and a new earth. The former things will not be remembered." Now, that verse could do with some discussion, and a deeper understanding. It would be worth having a few friends and neighbours over to discuss it. Finally, let us look at the wonderful verse in Revelation 21: 1. "Then I saw a new heaven and a new earth." When will this take place?

I suspect the verses we need are those spoken by Christ himself. He referred to the Kingdom of Heaven as we see in Matthew 4: 17. God's kingdom is not to be relegated to a place, i.e. heaven up there in the blue yonder. "The Kingdom of Heaven is at hand......"

Jesus said. Those who follow Jesus receive a wonderful reward for "your reward is great in heaven" (Matthew 5:12).

Again Jesus spoke of heaven as God's dwelling place, as in the Lord's Prayer: "Our Father who art in Heaven" Also, we need not fear death, our physical death. Even though the wages of sin is death (Romans 6:23) Christ himself shows us the way to eternal life, through our belief in Him as our Saviour. (John 5: 21)

Finally, as with the persecuted Christians of the early church period, if we are faithful unto death, Christ will give us the crown of life. (Rev. 1:10), That sounds good to me, I trust Jesus to walk with me along my Life's Labyrinth, and when I come to the end He will be there to say: "Well done, good and faithful servant. Enter into the joy of your Lord." (Matthew 25:21) This is the total truth which goes deep into us as we walk with Christ along our Life's Labyrinth; He will see us to the end and what a great banquet there will be!

What will God's Kingdom be like? Revelation 22 paints a wonderful picture of an eternal realm where the river of life flows from the throne of God. On each side of the river stands the tree of life bearing twelve crops of fruit, yielding its fruit every month. And the leaves of the tree are for the healing of the nations. This says to me that heaven is a place of healing, a home where we will be completely healthy. There will be enough of everything for God is the almighty provider, from the beginning to the end.

Yes, God has both the beginning and the end Word, and that is just fine by me. I totally trust His provisions

and His daily leading. His Spirit fills my life with peace and joy, and when He is ready to call me home I will go singing His praises for all eternity. Christ does lead us through our Life's Labyrinth, our human life here on earth. His Spirit turns each human decision for us into a well planned and joyful event, eventually leading us home. We follow Jesus' cross until we reach the end – Heaven. It can be quite a journey, but we are never alone. Christ Jesus is beside us all the way.

CONCLUSION

OUR LIFE'S CENTRE

The purpose to walking a labyrinth is to centre down into oneself, to find our peace and serenity at our very centre. Finding Christ and putting Him at our centre is the goal for all of us. Jesus is the very reason for our human existence. The purpose of this life here on earth is to discover, as His followers, the way to finally reach that glorious center, Heaven – our eternal home.

So, as you and I come close to the end of our journey with Jesus, to the end of our walk through this world along our Life's Labyrinth, it is only appropriate that we talk about our real centre as human beings, for that is where we are heading, right? As this labyrinth has a centre, so does the human body, and that centre has direct connections with all we do, all we believe in and hope to be as we journey through life. Yes, we do have a centre, but where is it, and what is it? That

depends on how we use our centre, and what we pour into it throughout our life.

Maturity deals directly with our centre, for when our personality and experience is comfortable at our center we can fully accept ourselves as we are. We know what we are centered on and accept ourselves: that is wholeness; that is maturity! What we are centered on affects all we are and hope to be. But where is it and what is it based on? Do you even know what I am talking about?

Medical scientists talk about the brain as our centre. The brain controls everything in us, and as we age we sure know that is true. As speech stutters, memory fades and our energy goes spiff, what are we becoming? Our brain is faltering and we feel lost and unsure as the deteriorating brain affects our bodies. This involves far more than just our thinking.

In relation then to our brain, where is the soul? Where is the spirit in us? These are fascinating questions that we cannot answer in this book. However, be sure of this one fact, our center is also connected to our soul and God knows how it affects us all at the spirit level. If we have focused on negative things all our lives, having grown up under a parent's negative influence, God knows why we feel lost.

Theologians argue over where and what is the connecting point with God. They call the soul our personality and they point to the spirit as that of God in us, whereby we connect with God. Whatever the word is we use to describe the spirit we all know there is a hole in us somewhere when we do not know

God. We feel the pull of that hole and try to fill it with drinking, or partying or sex – on and on. It could be money we use to fill that hole. This last, money, is probably the harshest and most prevalent in today's society, but it does not fill the hole one bit. There is a lot of suffering everywhere and people aimlessly try to fill their lives, fill the hole.

Does reading this book help? There is an answer to our personal suffering and that is to reach for a connection with God. This is why Jesus came, to provide that connection with His Father for us humans. The sad part is, few have really touched base with Jesus. They are turned off by some form or other of human bungling, like arguments in church over the coffee, etc. But in this final and utterly important question of what fills the hole in us, all arguments and questions seem so incomplete and fruitless. Jesus turns all such arguments on their head through His crucifixion and resurrection. The true centre of every Life's Labyrinth is Jesus Himself. In Jesus we fill up: He offers us life, He offers us eternity. He is our centre!

In this modern day, when churches are emptying fast and youth are falling away from granddad's faith, what can be done? For many, their center is emptying fast, not from war and rumours of war, but from ignorance and rumours of better things elsewhere. In this age when Sundays are no longer worship days, how does one find time for church, or even for thinking about God? Interest fades for there is little or no spiritual input in busy lives. The western world is moving forward much too fast. Instead of personal relationships, where a hug from a friend or loved

one is so fulfilling, there is the twitter message, fast and short. Interesting yes, but no hug! The personal touch is missing.

What can Christians do in the middle of such emptiness? If we look back to the Early Church period they didn't have large, fancy buildings in which to worship. They slipped quietly into catacombs, among the dead, in hiding. The emphasis on the church as a building of worship has been the focus since Emperor Constantine in 300AD. I wonder if that focus is changing these days, and to what is it changing? Where is our center for worship now if we can't get to a church in our busy lives? Where is Jesus leading us to these days as we look for our centre?

The point here is that Jesus Himself is walking through our Life's Labyrinth with us. He is beside us, but the personal relationship with Him has been ignored by many as they flit from one church to another, or quit all together. This situation, though, does not change the truth about Jesus, His Spirit is here walking beside us. The problem exists when we ignore Him. All we need do is turn to Christ Jesus and say, 'I'm sorry. I didn't really know you then, but now I see you. Please come into my life.' Then you receive what feels like a warm, accepting hug and you are filled. It is love that fills your hole, the love of God's acceptance as the Holy Spirit fills you. One can feel the difference almost immediately, the hole inside begins to fill up, and in our center now is the love of God. There is nothing like it on earth – a divine hug! And the pain from all we have done evaporates as we ask for forgiveness

and receive it. Something takes over inside us and it feels so right.

The filling of our centre, that spiritual hole in us, is a personal experience with Jesus, filling us with His love and joy. Our centre now is always full, ready to spill over, and it takes us out of the church building to our neighbours, and work associates. It can and should be, shared with others. There is something strange about us; others notice and wonder. What does she or he have that I don't? Let us listen carefully now. Our centre is full and overflowing. Thank you, Lord.

Our walk throughout our lives is on a Labyrinth, but it has never been a lonely one. We have walked continuously with Jesus. When we have had problems it has been due to our neglect of Him. Now, what can we do to tell others? They will be noticing immediately that our hole has been filled. It will be showing on our faces. It is wonderful to share the divine hug with others.

Can you invite a few friends to your home now to tell them that your hole has been filled, and how it happened? Maybe, this is the future for the Church – as it has always been Christ's body - as we share together and worship together in a private home somewhere. Or, maybe churches will remain open all day, every day for worship and private prayer. Jesus, though, will always find you and be there in your midst to give you a huge hug. He says, "I am here and I love and forgive you." Wow. You are at home in your spirit and your soul sings. You have reached

the center of your LIFE'S LABYRINTH and finally found the real, fulfilled and happy you!

> *"I'm telling you these things while I'm still living with you. The Friend, the Holy Spirit whom the Father will send at my request, will make everything plain to you. He will remind you of all the things I have told you. I'm leaving you well and whole. That's my parting gift to you. Peace.*
>
> *I don't leave you the way you're used to being left—feeling abandoned, bereft. So don't be upset. Don't be distraught. You've heard me tell you, 'I'm going away, and I'm coming back.' If you love me, you would be glad that I'm on my way to the Father because the Father is the goal and purpose of my life."* (John 14:25-27, 28) The Message (MSG)

God is the goal and purpose of your life and mine, and Jesus IS coming back someday. We thank God for His loving care as we walk with Christ's Spirit along our Life's Labyrinth. Have a wonderful journey, and I will see you in Heaven.